Danielle Lucas
Suns, Moons & Stars, Hearts, Flowers & Butterflies

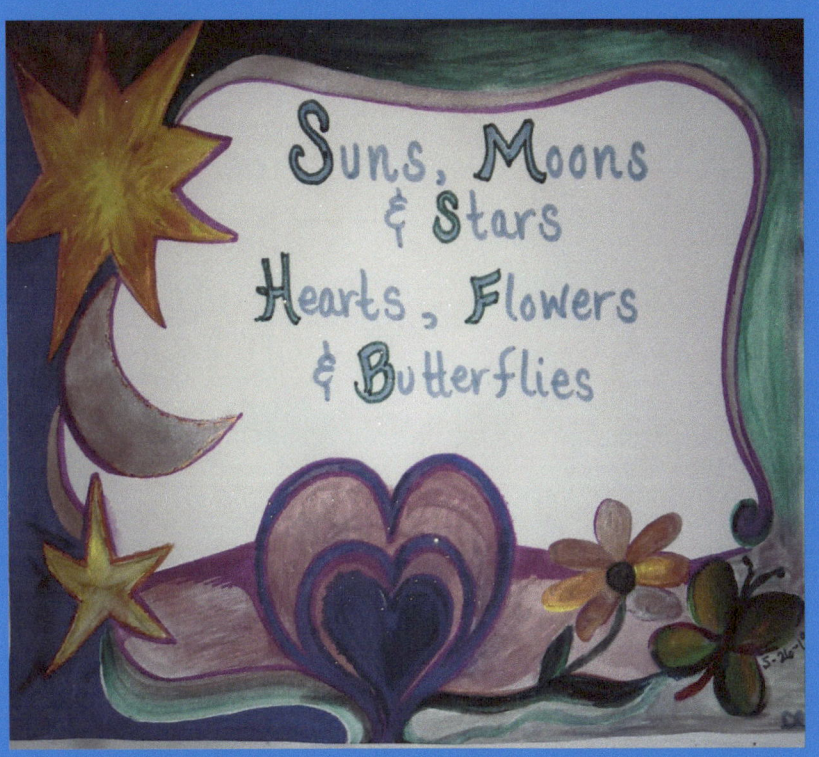

Immersing oneself into healthy hobbies helps with overall well-being and self-esteem. Many of my creations are a form of therapeutic healing in times of high stress.

I use a variety of materials to create images. These include paints, glue, yarn, fabric and recycled items that would otherwise be thrown away. I am trying to do a little part to save the environment while creating a little more peace and harmony.

Danielle Lucas, Experimental Expressionist

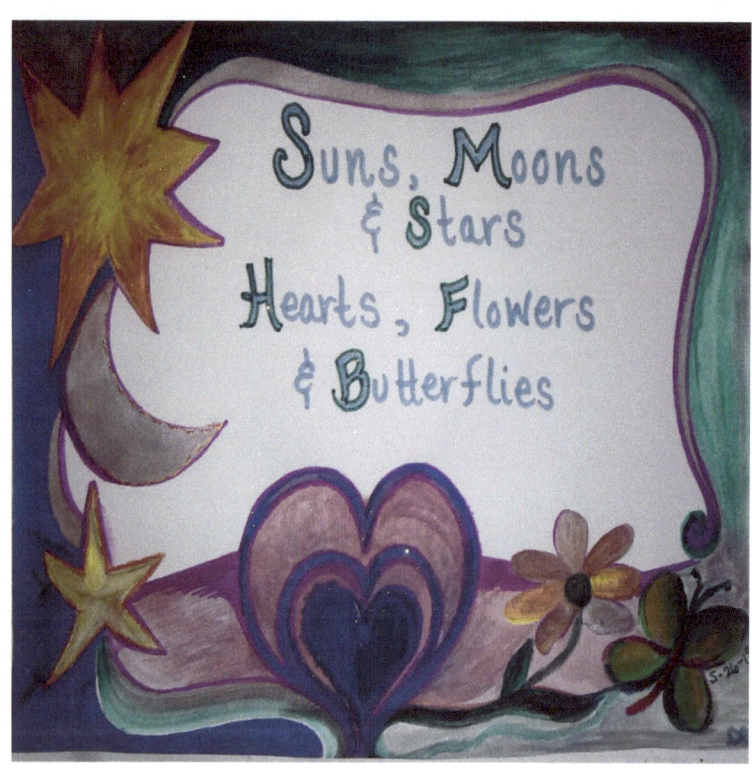

With thanks to my children, for without them none of this would be possible.

To Change the World, Love Your Family
36" x 24"
Includes:
Flower in the Center of the Sun Swirl
Sunshine Fern
Flowers Swirl in the Sun

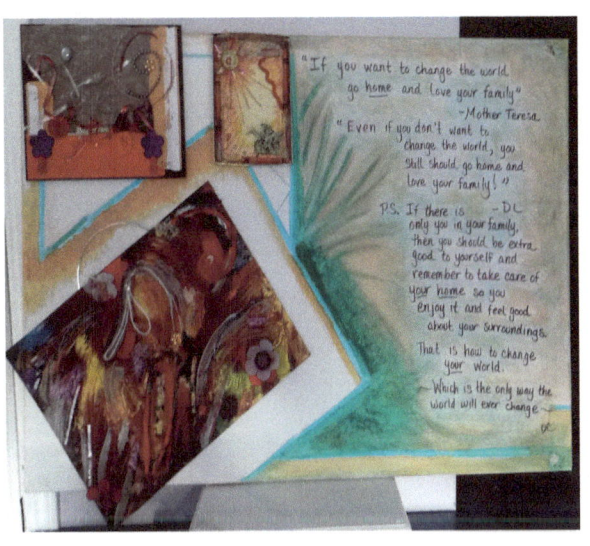

What ways would you change the world?

If you could change one thing in your life right now what would it be?

To Change the World, Love Your Family

Flowers in the Center of the Sun Swirl
April 2019
Mixed Media Collage
10" x 8"

What objects do you see in this mixed media collage?

How do you think this piece relates to changing the world?

Glass gems are wishes. Make your wish to change the world.

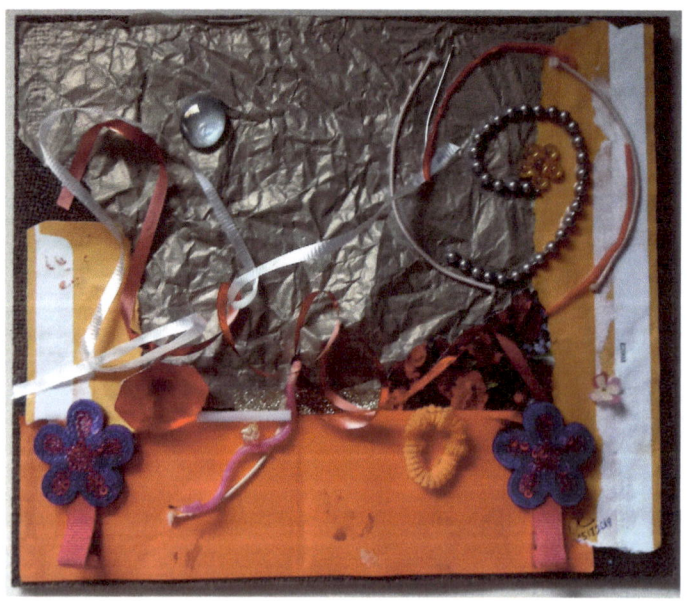

Flowers in the Center of the Sun Swirl

What needs sunshine?

What happens when the world becomes too warm from the sun?

If you could be a plant, what type would you be?

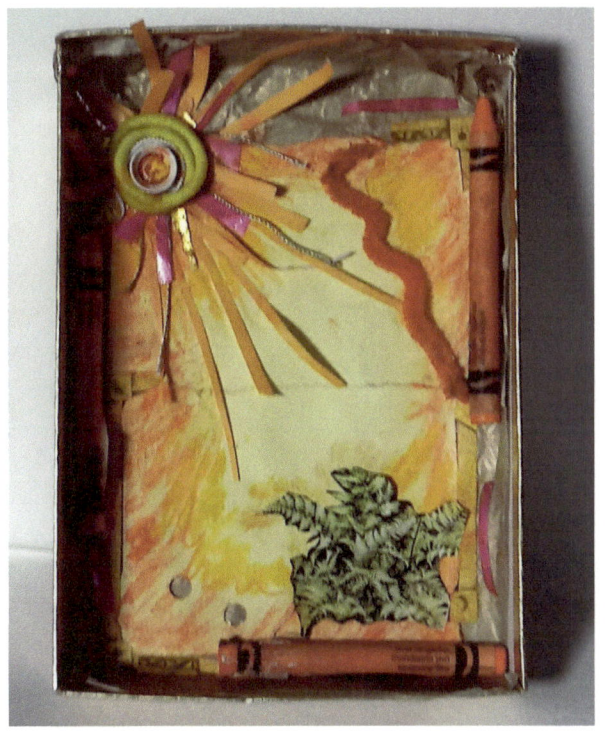

**Sunshine Fern
April 2019
Mixed Media Shadow Box**

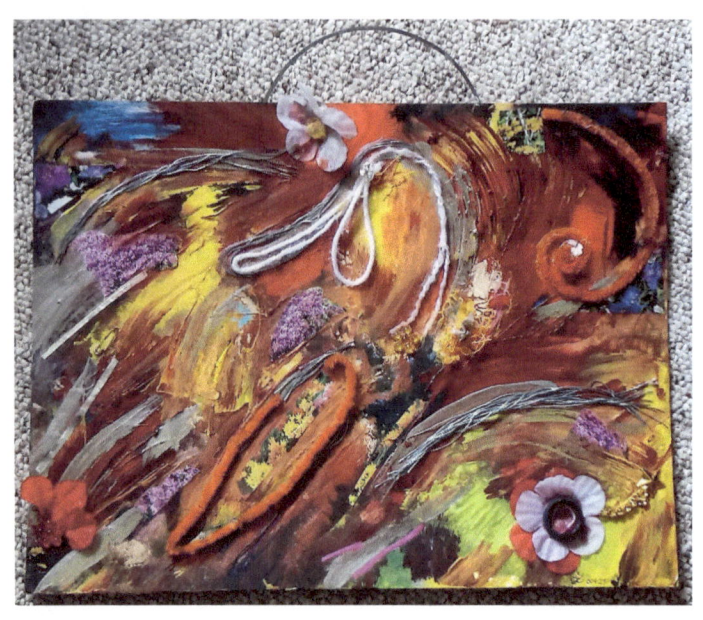

How many flowers can you find?

What other things do you see in this mixed media painting?

How does being in the sunshine make you feel?

What kinds of things do you like to do during sunny days?

Flowers Swirl in the Sun
May 2019
Mixed Media Painting
15 1/2" x 11 1/4"

Flowers Swirl in the Sun

Suns, Moons & Stars:
18" x 24"
Includes:
Sunrise Sun
Yellow Crescent Moon & Star
Heart in the Center of the Sun
Silver Moon & Star
Sun of Many Colors
Wish in the Center of the Sun &
Blue Crescent Moon

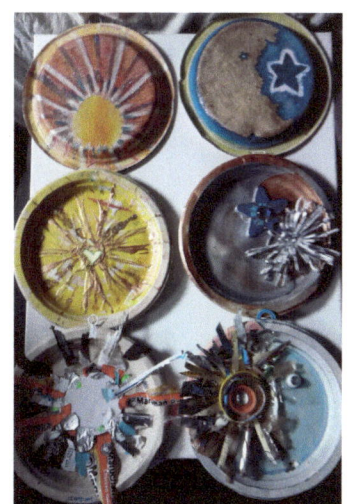

Why do you think the Suns, Moons & Stars are arranged this way?

What colors do you find most appealing?

Sun, Moon & Stars

What do you see when you look at this painting?

What does it make you think about?

Can you count the lines that you see by colors?

What shapes can you find in the painting?

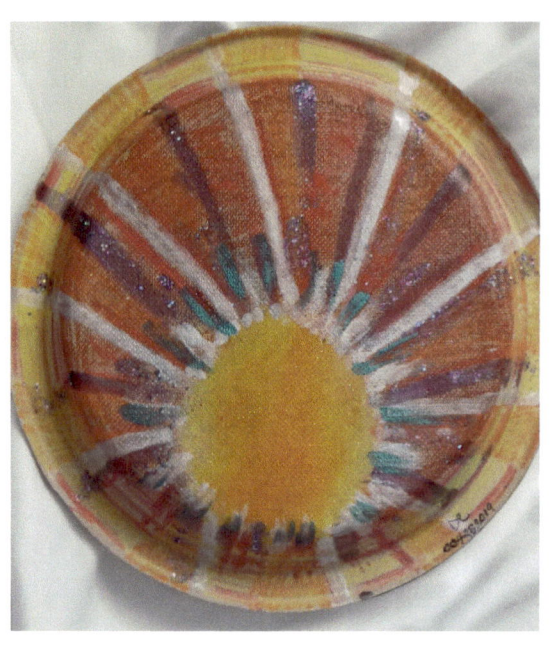

Sunrise Sun
April 2019
Mixed Media Painting
9" Plate

Sunrise Sun

Yellow Crescent Moon & Star
April 2019
Mixed Media Painting
9" Plate

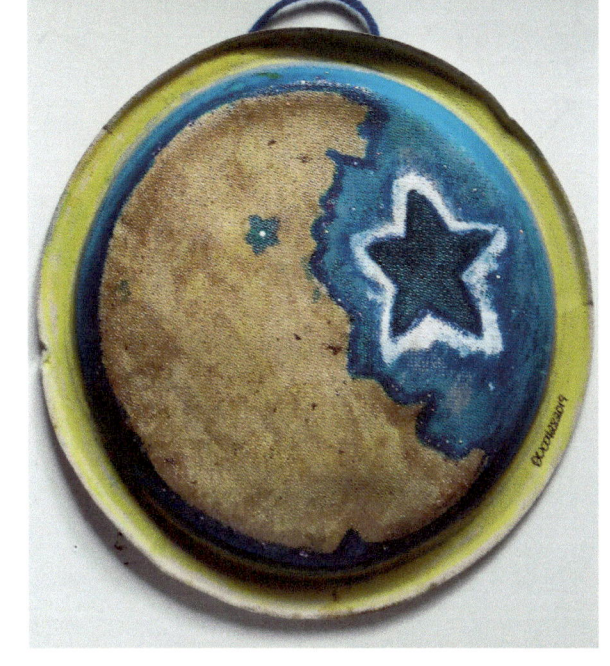

What does this make you think about?

What else do you see in the images?

Yellow Crescent Moon & Star

What does this image make you think about?

How many lines can you find?

Why do you think the heart is in the center?

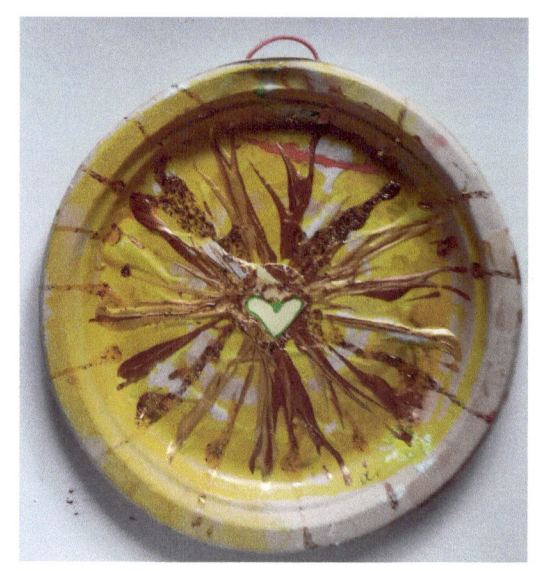

Heart in the Center of the Sun
May 2019
Mixed Media
Painting
9" Plate

Heart in the Center of the Sun

What colors do you see?

What does this image make you think about?

Fun Fact: The glue around the glass gem is glow in the dark glitter glue.

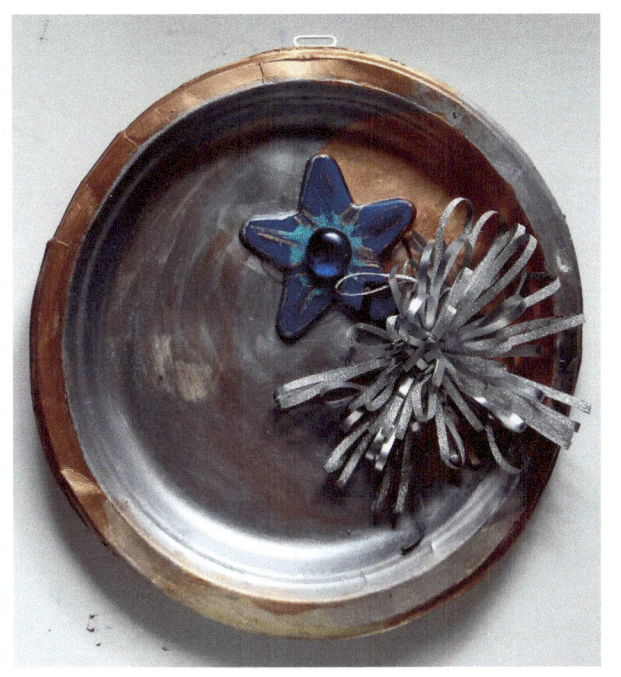

**Silver Moon & Star
May 2019
Mixed Media
Painting
9" Plate**

Silver Moon & Star

What colors do you see in this sun?

How many different types of wrappers can you find?

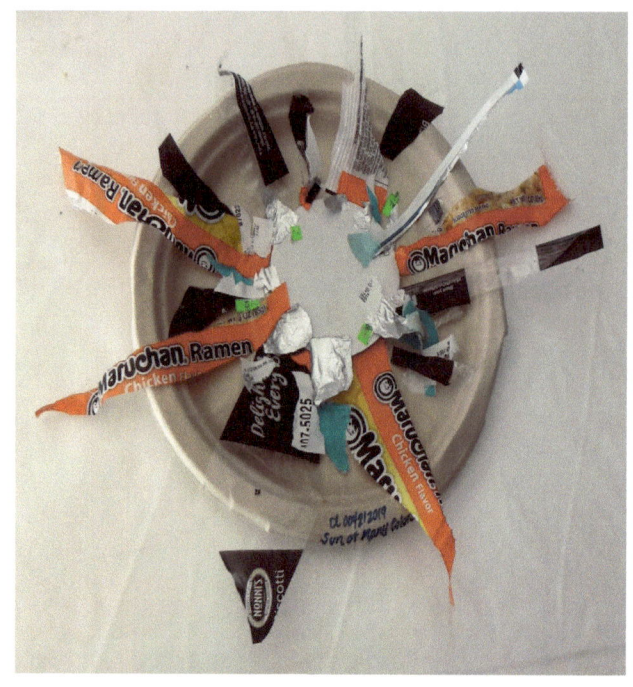

Sun of Many Colors I
April 2019
Mixed Media Collage
9" plate, 14 1/2" from the longest edges

Sun of Many Colors 1

If you could make a wish on the sun, what would your wish be?

How many different food wrappers can you see?

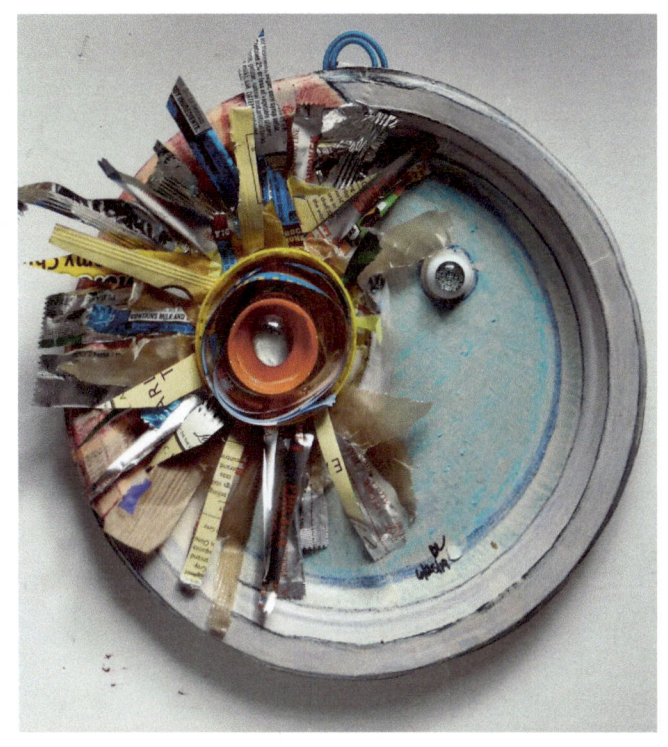

Wish in the Center of the Sun & Blue Crescent Moon
June 2019
Mixed Media Collage
9" Plate

Wish in the Center of the Sun & Blue Crescent Moon

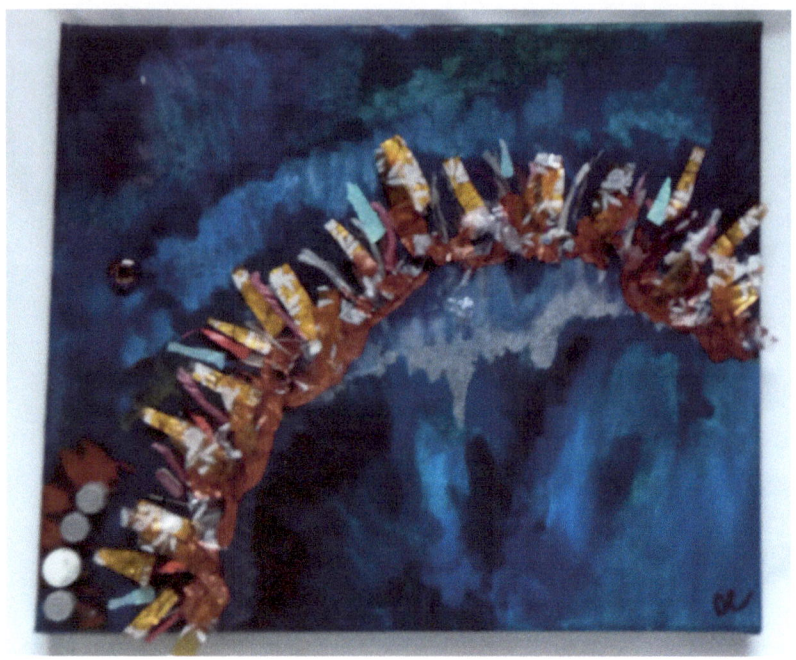

Why do you think this mixed media painting is titled "Fire Sun"?

What do you think about when you see this?

How many different types of food wrappers do you see?

Fire Sun
June 2019
Mixed Media
Painting
10" x 8"

Fire Sun

How many colors can you see in this piece?

What do you think of when you see this shadow box?

Can you think of a time that you caused a splash?

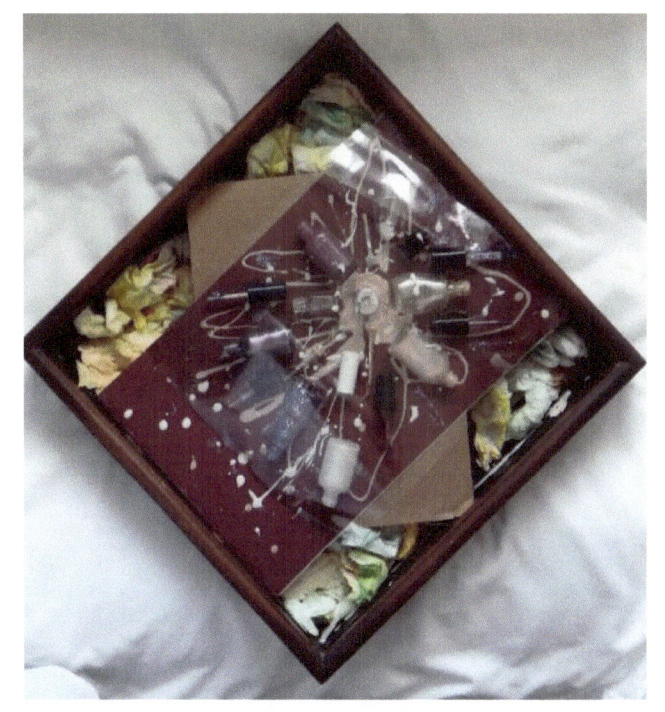

Sun Splash of Colors
June 2019
Mixed Media Shadow Box
21" x 21" Diagonal

Sun Splash of Colors

**Solar
January 2019
Mixed Media
Collage
8" x 10"**

What objects do you see in this image?

What do you think about when you see this collage?

If you could make an energy power what kind would it be?

What kinds of things need solar power to survive?

**Twin Suns Includes:
Yellow Sun
Red Sun**

What similarities do you see with these two pieces?

What differences do you see?

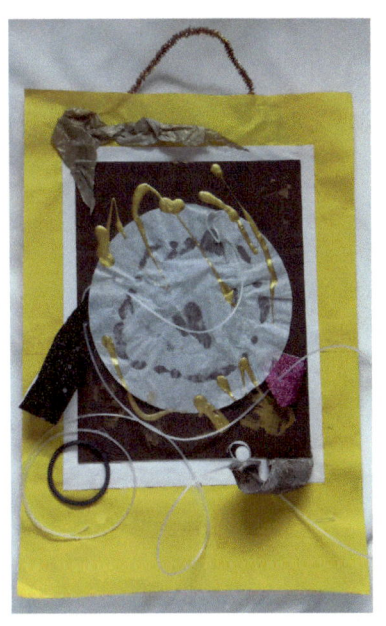
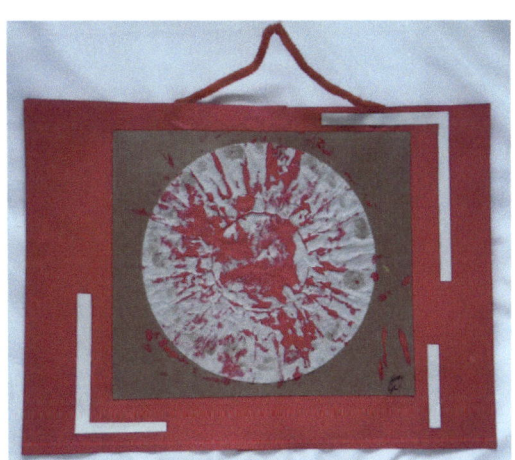

Twin Suns

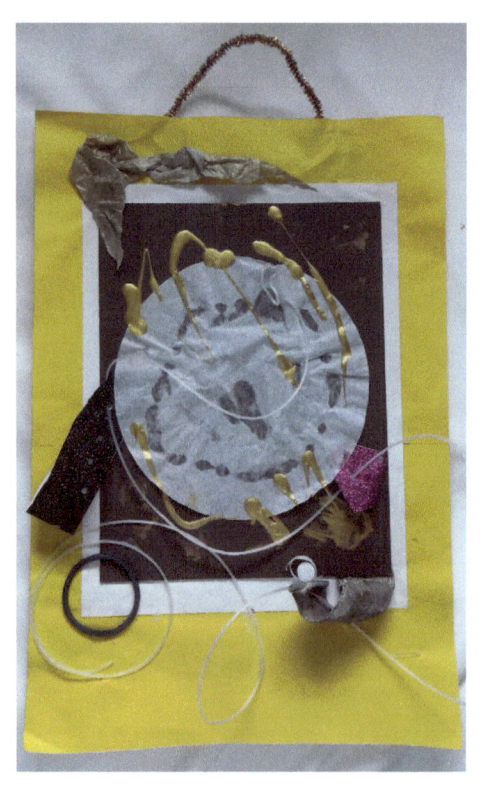

What objects do you see in this image?

What do you think about when you see this collage?

What things do you like to do in the sunshine?

Yellow Sun
April 2019
Mixed Media Collage
11" x 16"

Yellow Sun

**Red Sun
February 2014
Matted June 2019
Mixed Media
Collage
15" x 11"**

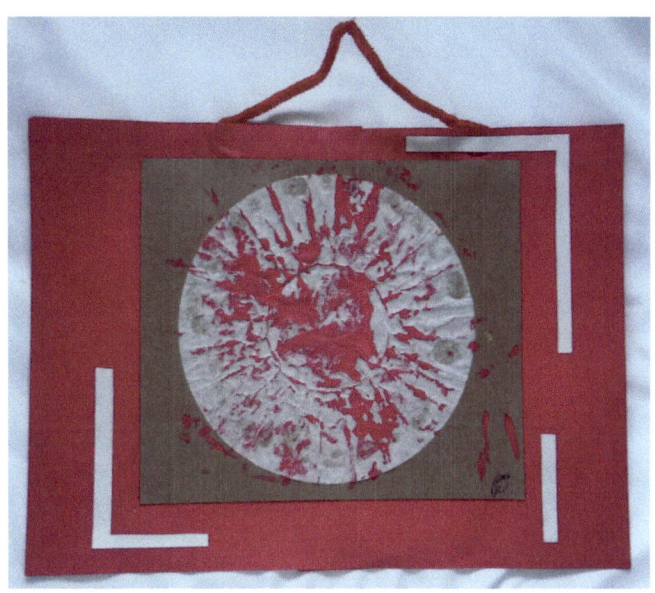

Have you ever seen a red sun?

How do you think this mixed media collage was made?

What does this image make you think about?

Red Sun

Why do you think this mixed media painting is titled Sun Burst?

Have you ever felt as though you could burst? What made you feel that way?

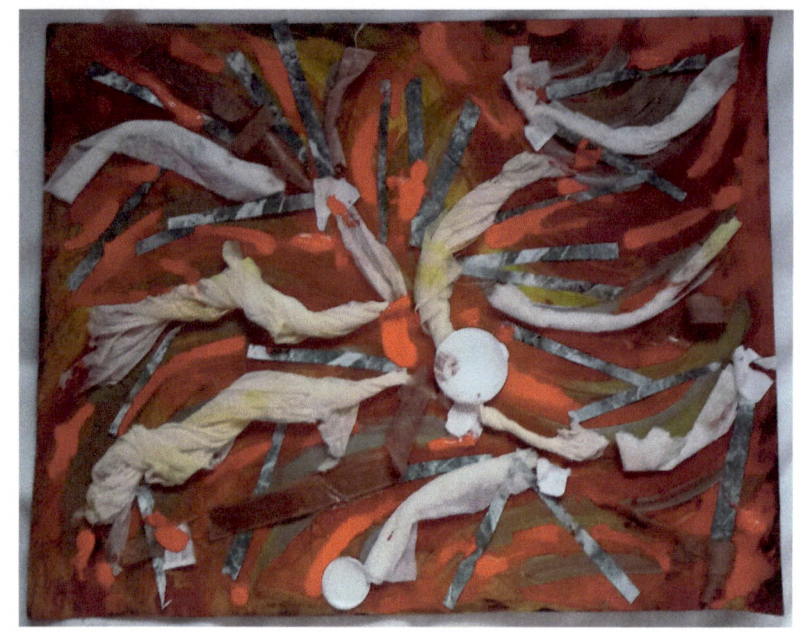

Sun Burst
May 2019
Mixed Media Painting
14" x 11"

Sun Burst

What objects do you see in this image?

What do you think about when you see this painting?

Can you think of a time when you saw the sun and the moon in the sky at the same time?

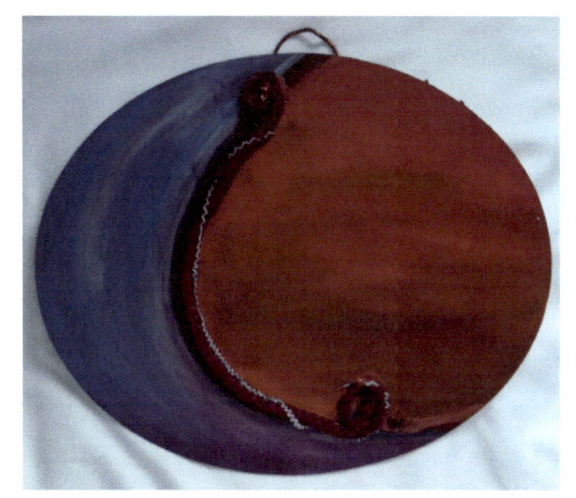

Copper Sun, Silver Moon
June 2019
Mixed Media Painting
10 ½" Oval

Copper Sun, Silver Moon

These are wooden shapes glued to paper. Some were painted before they were glued and some were painted afterwards. Can you see which ones were painted before and which ones were painted after?

What shapes do you see?

How many circles and squares can you find?

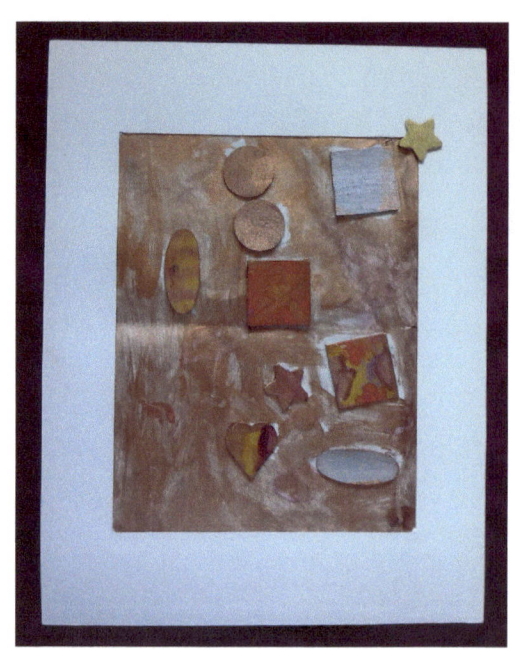

**Wooden Stars
July 2018
Mixed Media
11" x 14"**

Wooden Stars

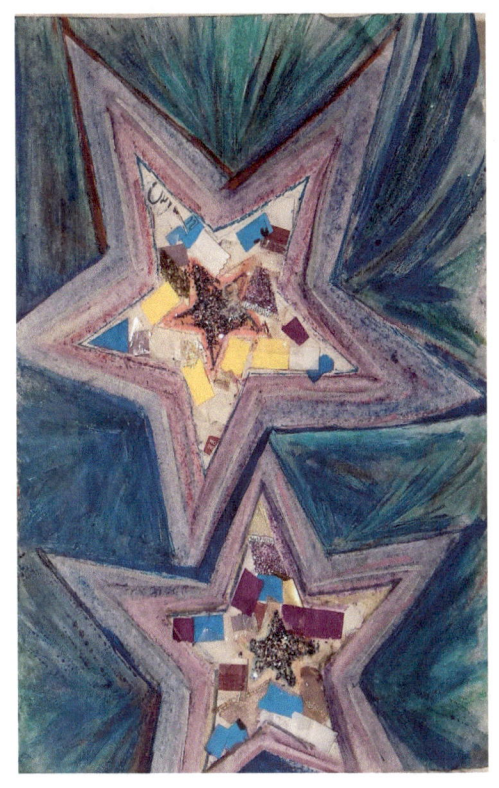

**Burst 1
December 2018
Mixed Media
Painting
10 ½" x 14"**

What do you see in this picture?

How many Star shapes can you find?

How many colors can you see?

If you could be any kind of star, what colors would you be?

Burst 1

**Moon Flowers
June 2019
Mixed Media Collage
24" x 18"**

Why do you think this piece is titled Moon Flowers?

What season of the year do you think this is?

What colors make you think of night and what colors make you think of day?

What kind of objects do you see in this collage?

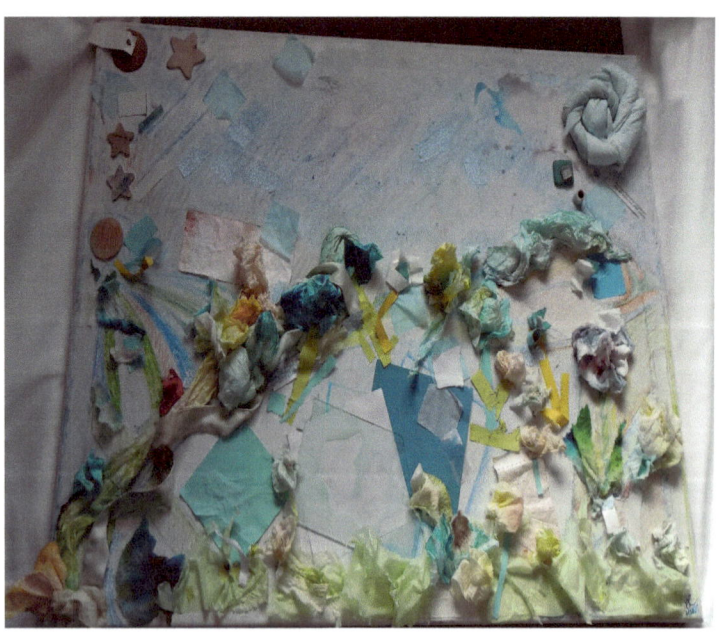

Moon Flowers

Three Hearts Bursting

**18" x 24"
Includes:
For Today, You are OK
Heart on a Plate
Heart Burst**

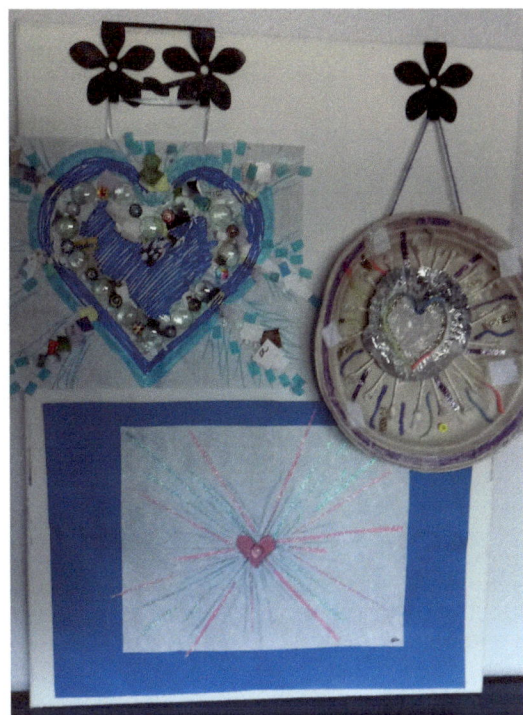

What similarities do you see?

Why do you think these mixed media collages are displayed this way?

Three Hearts Bursting

The Glass Gems are Wishes.

How many wishes did you make?

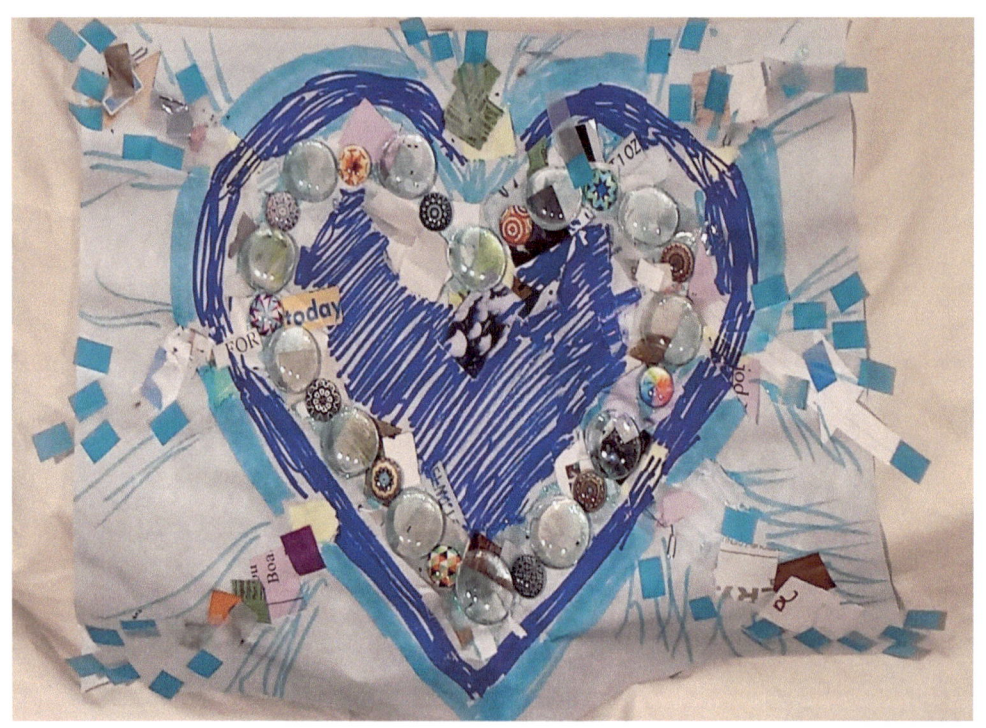

For Today, You are OK
January 2019
Mixed Media Collage
11" x 8 1/2"

For Today, You are OK

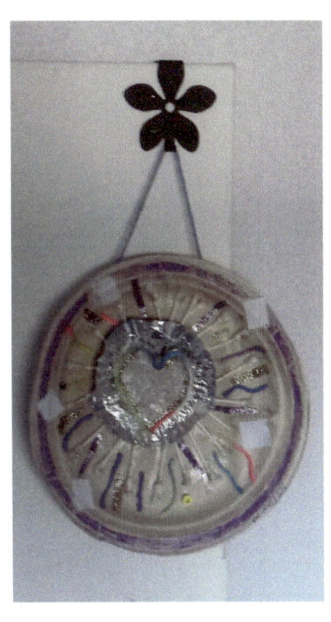 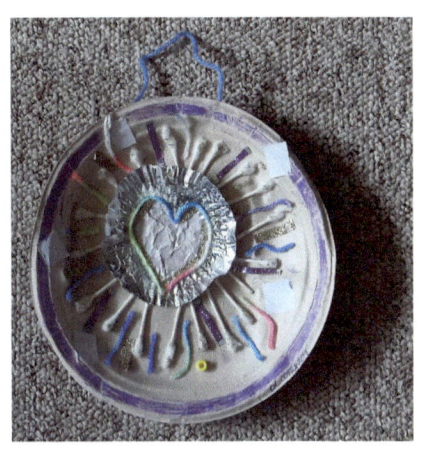

What do you see in this collage?

What do you think about when you see this image?

What similarities do you see with this piece and the other two pieces displayed in this set?

Heart on a Plate
April 2019
Mixed Media Collage
9" plate

Heart on a Plate

Heart Burst
December 2018
Mixed Media Collage
16" x 11"

What shape do you see in this collage?

How many lines do you see?

What do you think about when you see this image?

What makes your heart burst?

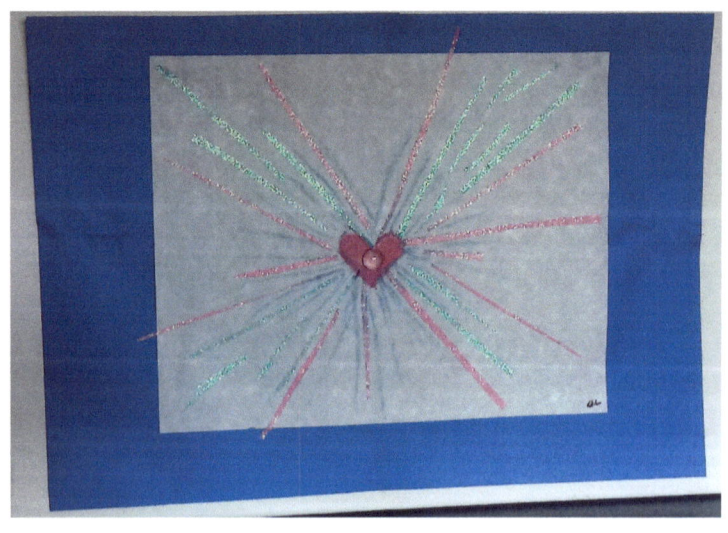

Heart Burst

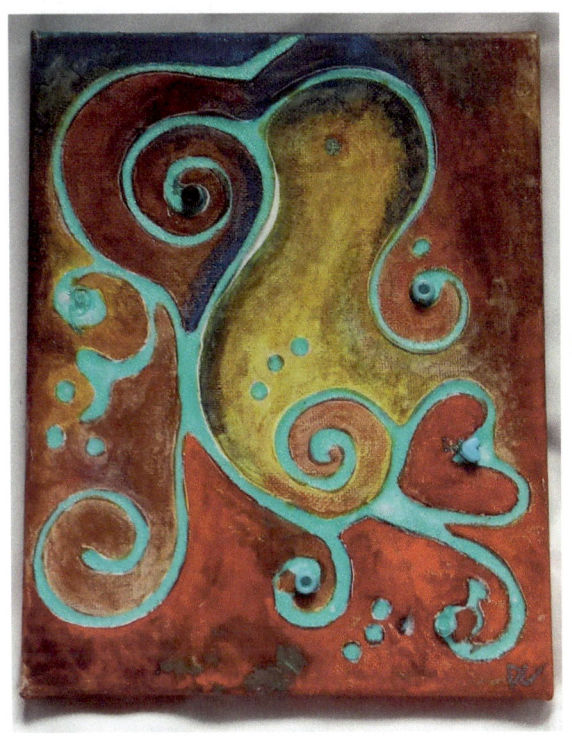

This mixed media painting glows in the dark in the areas that have the glow in the dark glitter glue.

Can you see the image it will make when glowing at night?

Heart Swirls
October 2018
Mixed Media Painting
8" x 10"

Heart Swirls

This mixed media painting glows in the dark in the areas that have the glow in the dark glitter glue.

Can you imagine what it would look like at night?

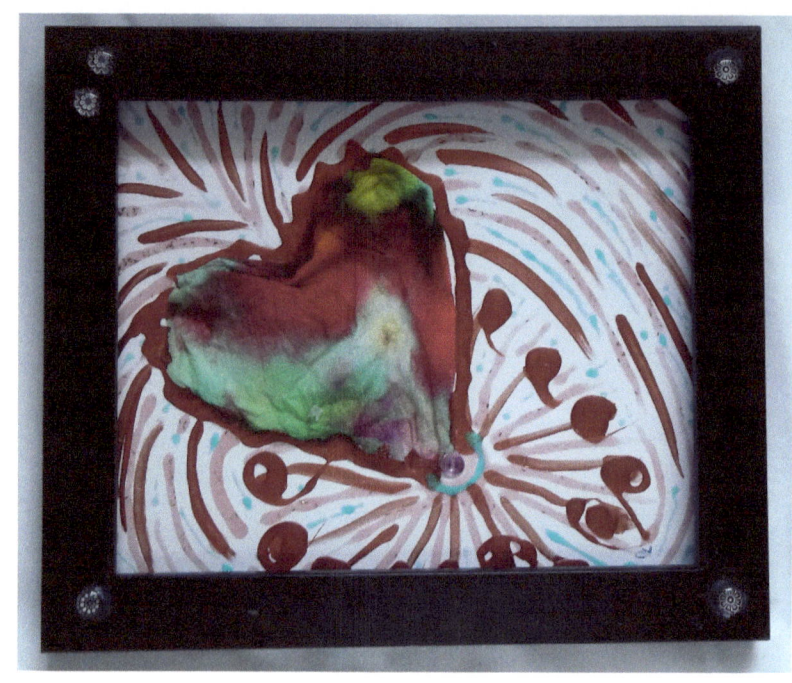

Night Heartbeats
June 2019
Mixed Media Painting
12" x 10"

Night Heartbeats

**Heart Ribbons
December 2018
Pastel Drawing
8 ½ " x 11"**

Why do you think the heart is made of ribbons?

Try to follow the ribbons with your eyes. Do they lead somewhere? Where do you think the ribbons go?

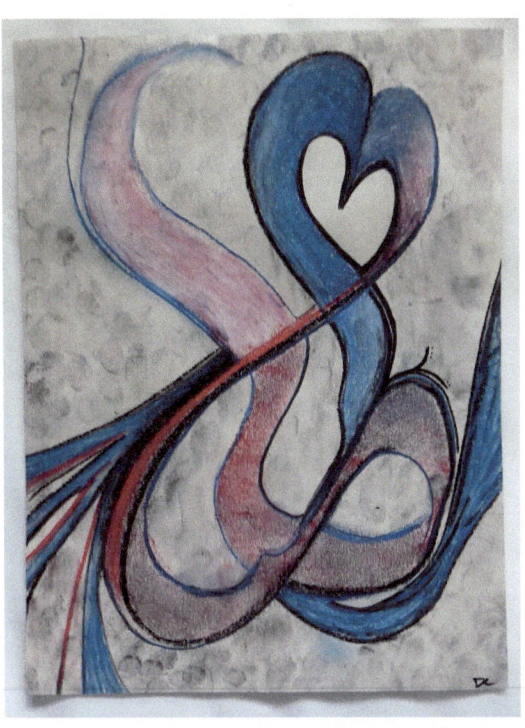

Heart Ribbons

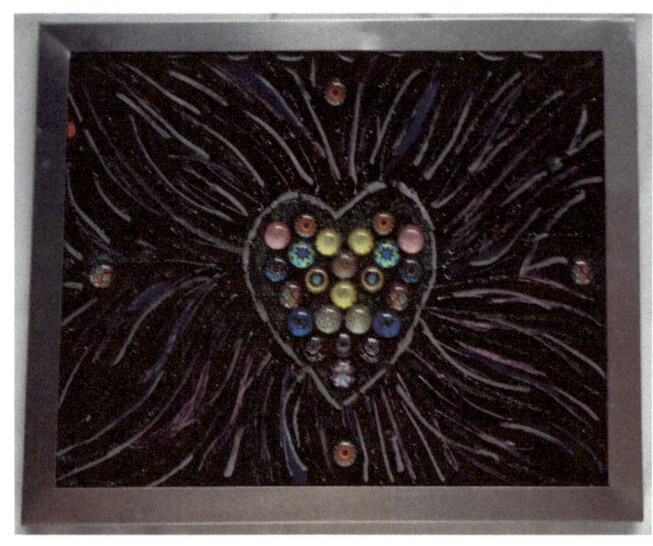

**Wish Upon a Heart
November 2018
Mixed Media
Drawing
10" x 8"**

Glass Gems are wishes. How many wishes are inside this heart?

What wishes would you make inside your heart?

What do you think the wishes on the outside of the heart are for?

Wish Upon a Heart

Have you ever tried to draw or paint on a t-shirt?

What colors do you see?

What objects are included into the design?

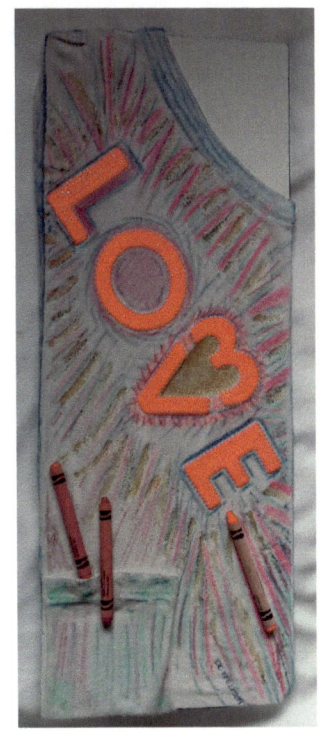

LOVE
April 2019
Mixed Media
T-Shirt
7 1/2" x 19"

LOVE

This is painted on clear plastic so another image can be seen when the light shines through the painting.

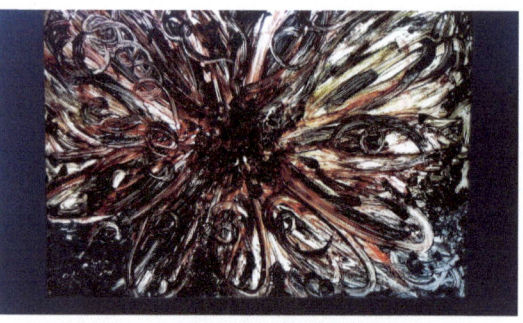

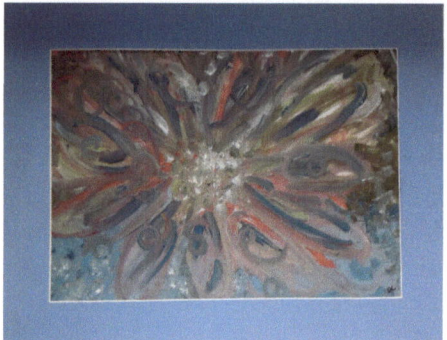

Can you see where the light would shine through?

Have you ever felt like others could see right through you?

What other things would you like to shine light through?

**Translucent Flower
December 2018
Acrylic Painting
24" x 18"**

Translucent Flower

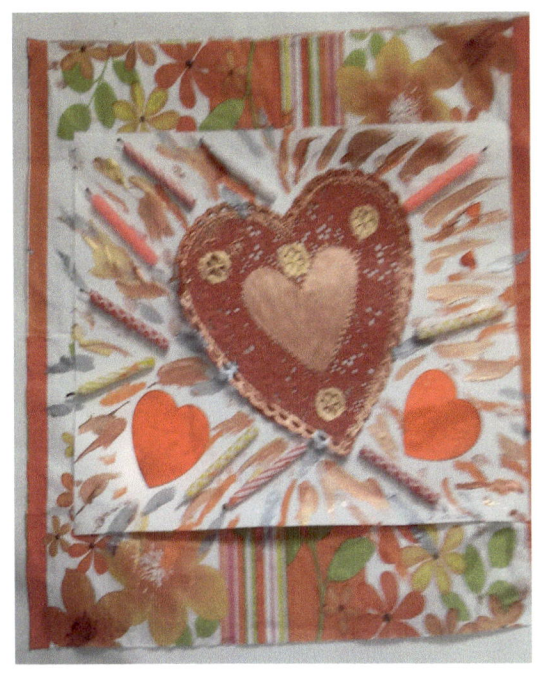

How many hearts can you find in this picture?

Can you count the candles?

Does seeing the candles in the artwork make you think of anything?

Can you find the Green stripes?

**Hearts and Flowers
May 2019
Mixed Media Collage
16" x 20"**

Hearts and Flowers

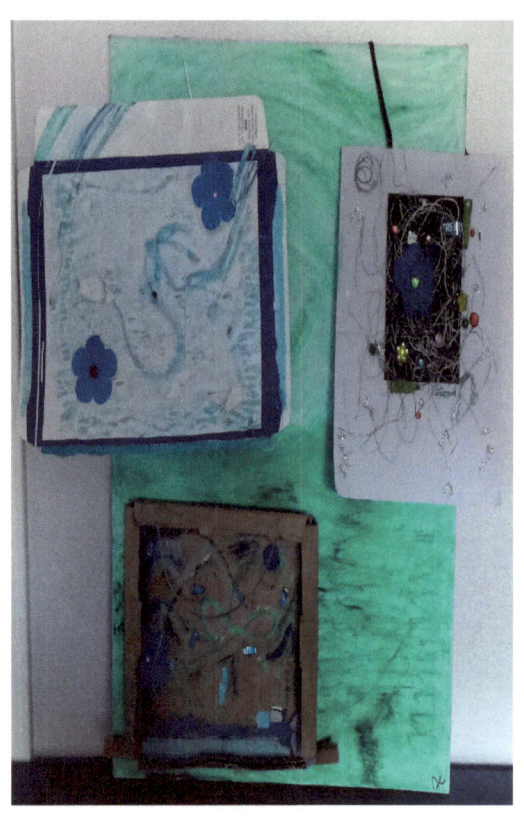

**Flowers Out to Sea
18" x 24"
Includes:
Aqua Sea Canvas
Blue Flowers in the Sky
Flowers in a Web
Flowers Swirl at Night**

What similarities do you see in these mixed media pieces?

What do you like about the way they are displayed?

Flowers Out to Sea

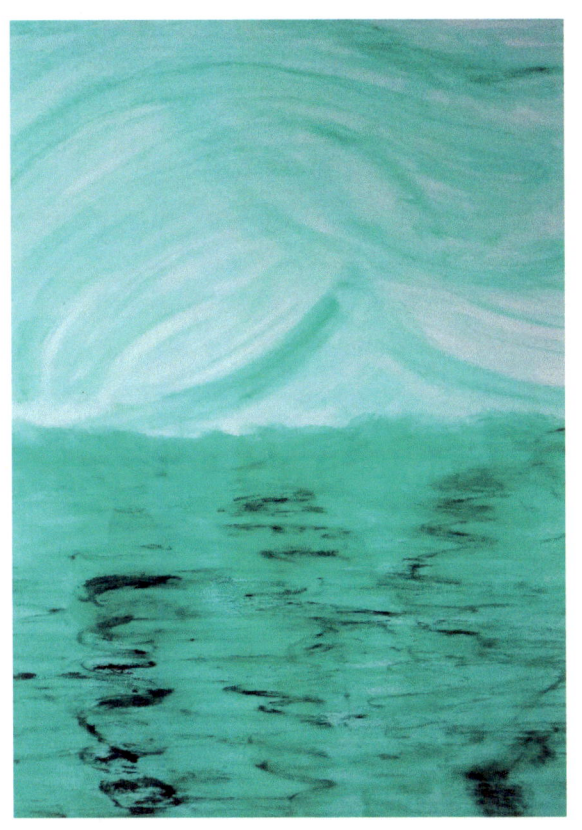

I painted this aqua sea while feeling very sad with grief. I think by hanging flowers over the grief and putting them "out to sea" gave me brief moments of feeling happy.

What do you do when you are feeling sad?

What kinds of things make you happier?

**Aqua Sea Canvas
December 2018
Acrylic and
Watercolor Paints
18" x 24"**

Aqua Sea Canvas

What do you see in this mixed media collage?

What do the colors make you think about?

If you could travel like a flower in the sky where would you go?

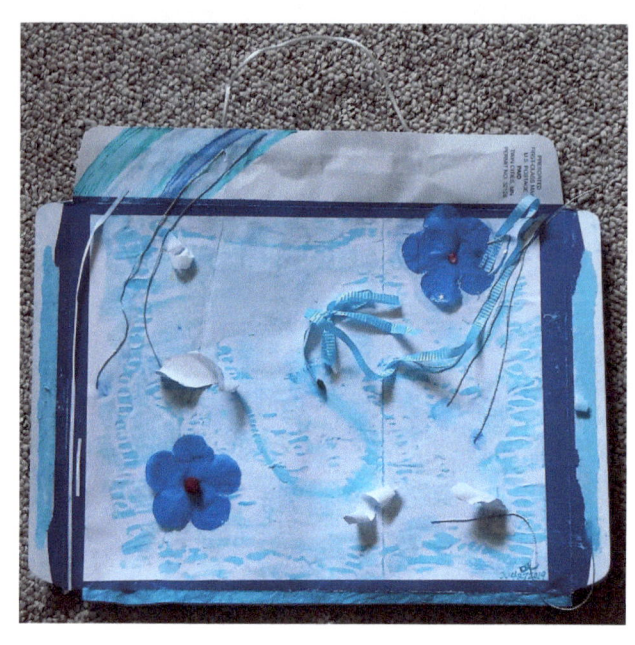

**Blue Flowers in the Sky
April 2019
Mixed Media Collage
14" x 11"**

Blue Flowers in the Sky

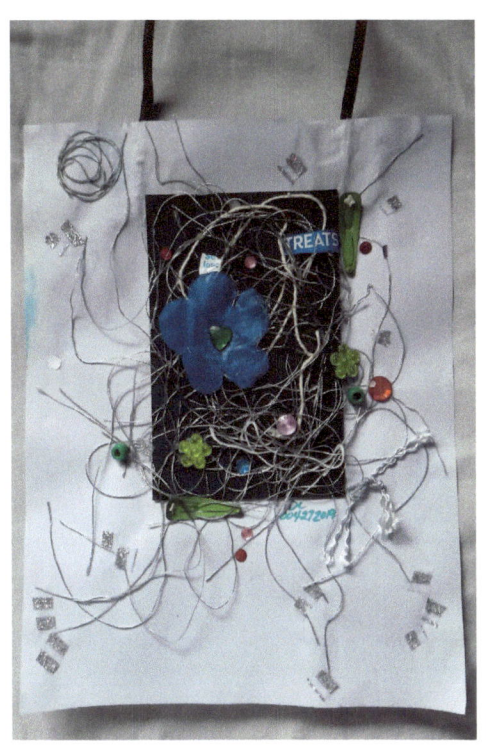

How many flowers can you find?

Sometimes life can be an intricate web and it is difficult to navigate.

What would you do if you were a flower caught in a web?

Flowers in a Web
April 2019
Mixed Media
Collage
8 1/2" x 11"

Flowers in a Web

This can be opened up when displayed on its own to reveal a hidden flower in the corner.

It was created with glow in the dark glitter glue so this also will reveal a hidden image at night.

Can you imagine what the image and can you find the moon in the night sky?

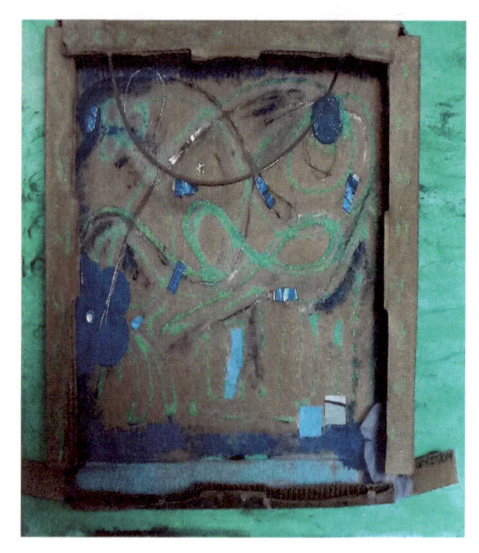

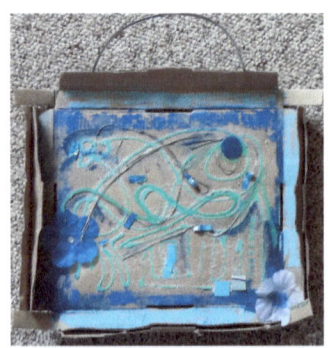

**Flowers Swirl at Night
April 2019
Mixed Media Shadow Box
10" x 9"**

Flowers Swirl at Night

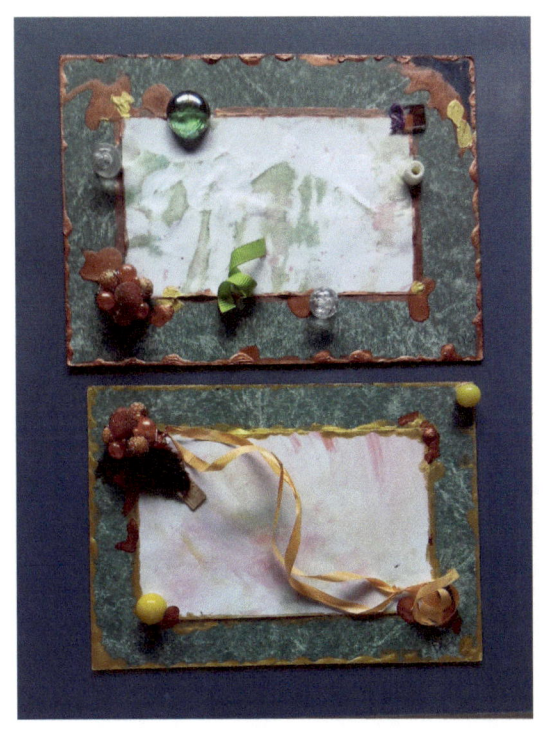

Gold & Copper Flowers
June 2019
Mixed Media Painting
9 1/2" x 12"

What do you find similar between the upper and lower parts of this mixed media piece?

What objects can you find?

Did you make another wish on the glass gem? What did you wish for this time?

Gold & Copper Flowers

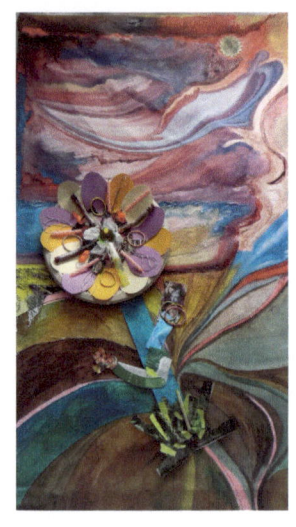

**Flower in a Diagonal Direction
June 2019
Mixed Media Painting and Collage
24" x 36"**

This is a painting made using watercolor paints. The flower was created separately and then glued into the painting. The canvas is purposely broken and then put back together to create an additional ripple effect.

What objects do you see in the flower?

Why do you think there are so many colors in this painting? What colors do you see? What does this painting make you think about?

Flower in a Diagonal Direction

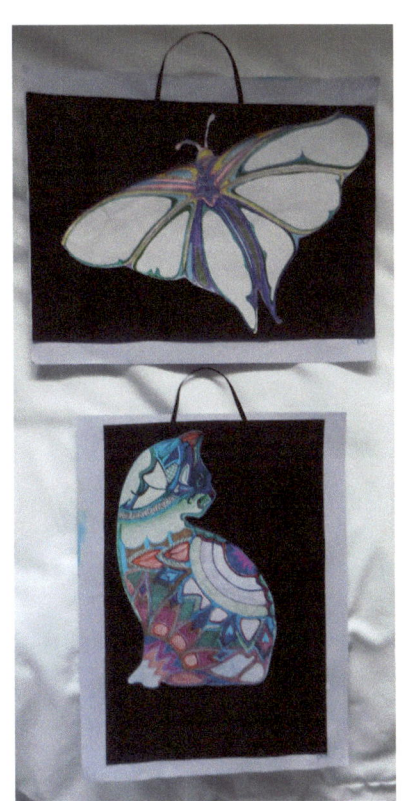

Lavender Designs Includes Lavender Star Butterfly Lavender Cat

Why do you think these two design drawings are together?

What do you like about them?

What do you think the lower cat is looking at?

Lavender Designs

When you look at this drawing what do you see?

What shapes can you find?

What colors do you see in this drawing?

Lavender Star Butterfly
May 2015
Mixed Media Design
Drawing
11" x 8 1/2"

Lavender Star Butterfly

**Lavender Cat
May 2015
Mixed Media Design
Drawing
8 1/2" x 11"**

When you look at this design drawing what do you see?

What shapes do you see in the design drawing?

If you turned to look behind you what do you think you would see?

Lavender Cat

What images do you see in this picture?

Where do you think this butterfly is going? Where would you go if you were a butterfly?

What color would your sky be?

**Butterfly Silver Sky
June 2019
Mixed Media Painting
and Frame
9" x 11"**

Butterfly Silver Sky

What do you see in this painting?
What do you think is happening to the butterfly?

Would you want to be the butterfly in this painting? Why do you think this?

Butterfly Burst
April 2019
Mixed Media Painting
16" x 5 1/2"

Butterfly Burst

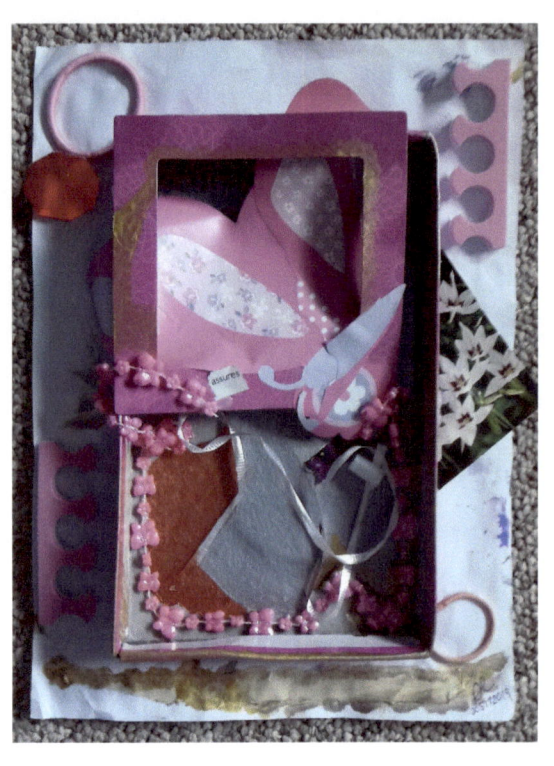

What do you see in this collage?

Where do you think the butterfly is going?

Have you ever turned back from going forward? How did you go forward again?

Butterfly Shadow Box
May 2019
Mixed Media Collage
8 1/2" x 11"

Butterfly Shadow Box

How many butterflies do you see in this coloring page?

Are there any butterflies that are the same?

Why do you think it is important to be an individual and wear your own colors?

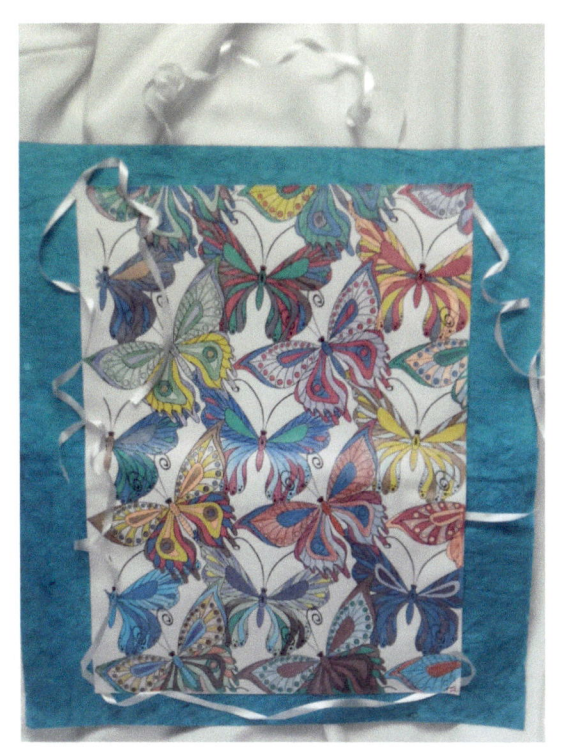

Butterflies Bursting
April 2015
Mixed Media Coloring
11 1/2" x 12"

Butterflies Bursting

Do you have a t-shirt at home that you could paint or draw on? What kind of design would you make?

Why do you think this butterfly is glowing?

Can you think of a time that you felt like you were glowing?

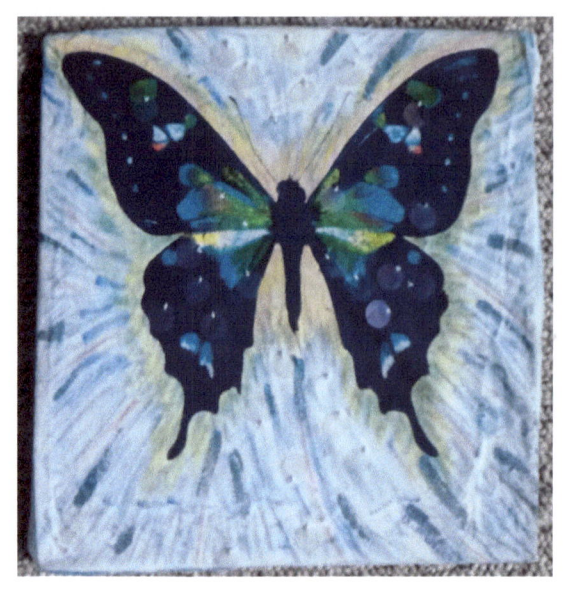

**Butterfly T-Shirt
April 2019
Mixed Media T-Shirt
11" x 11"**

Butterfly T-Shirt

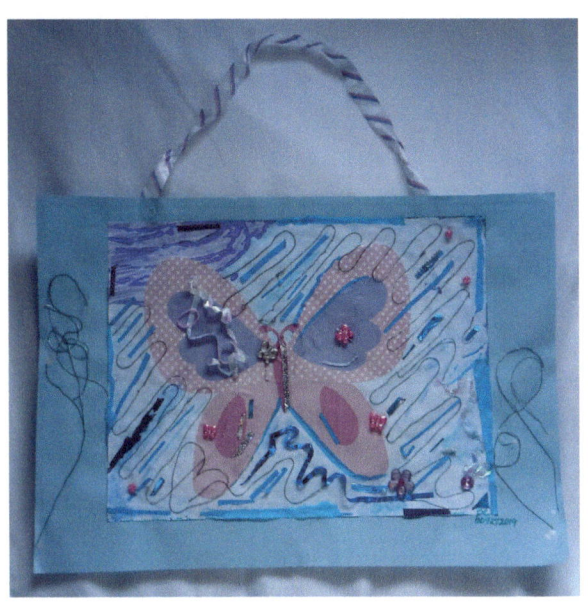

**Butterfly in the Sky
April 2019
Mixed Media Collage
16" x 11"**

Have you seen butterflies in the sky?

How do you think this mixed media collage was made?

What does this image make you think about?

Butterfly in the Sky

What are the wings made from?

Would you like to fly with wings?

What do you think it would feel like to be flying or soaring like a butterfly?

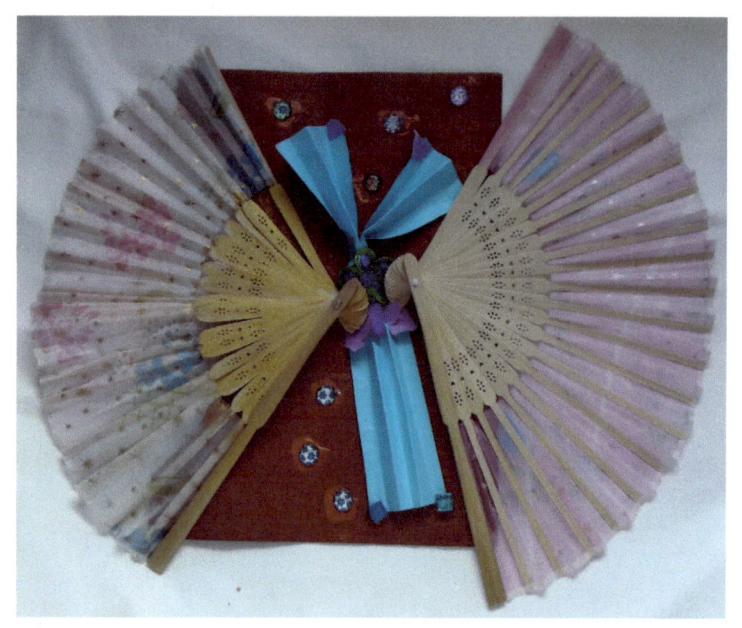

Butterfly Wing Fan
May 2019
Mixed Media Collage
16 1/2" x 14"

Butterfly Wing Fan

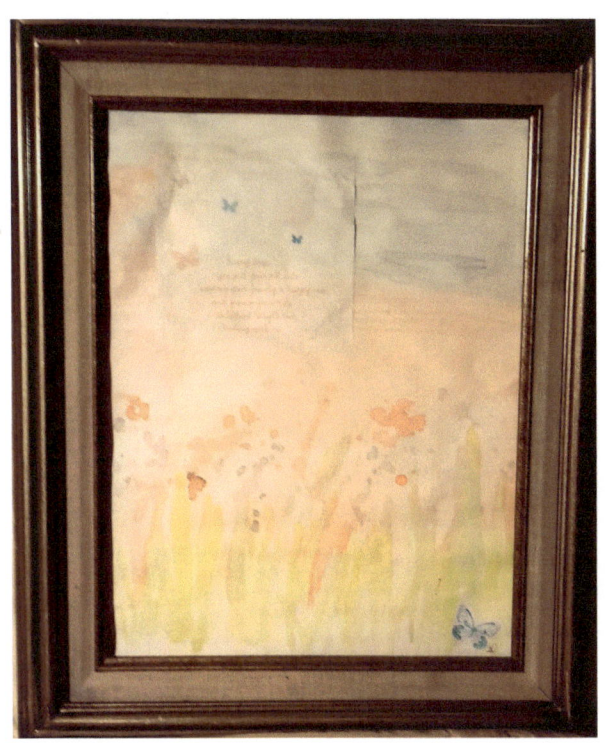

For Family
April 2015
Food Dye
Watercolor and Paper
18 1/2" x 15 1/2"

What do you see in this picture?

What kind of memories does this painting make you remember?

For Family

**For the Child that Wasn't
2008
Mixed Media Painting
24" x 18"**

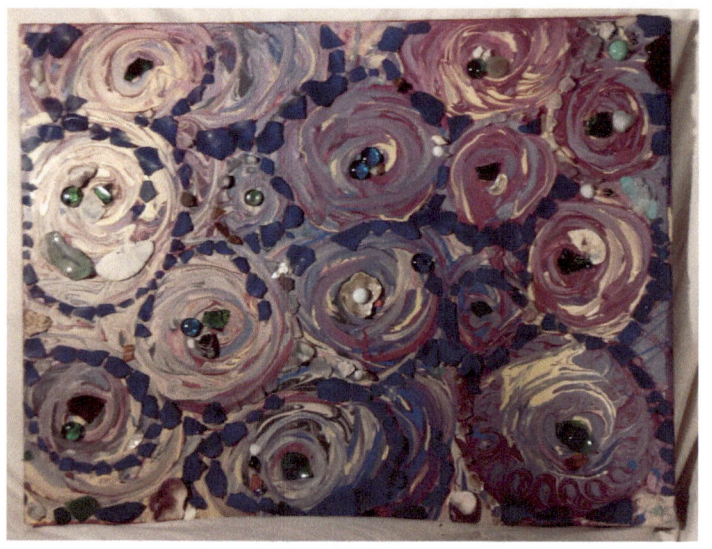

What objects do you see in this painting?

What shapes do you see?

When you look at this painting what do you see?

For the Child that Wasn't

When you look at this painting what do you think of?

What colors do you see?

What ways do you love your family?

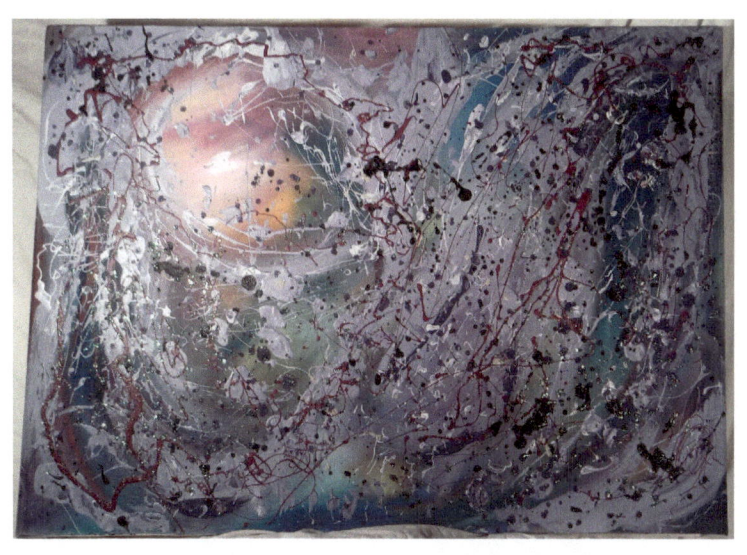

**For My Children
2010
Mixed Media
Painting
42" x 29 1/2"**

For My Children

Danielle Lucas
Suns, Moons & Stars, Hearts, Flowers & Butterflies

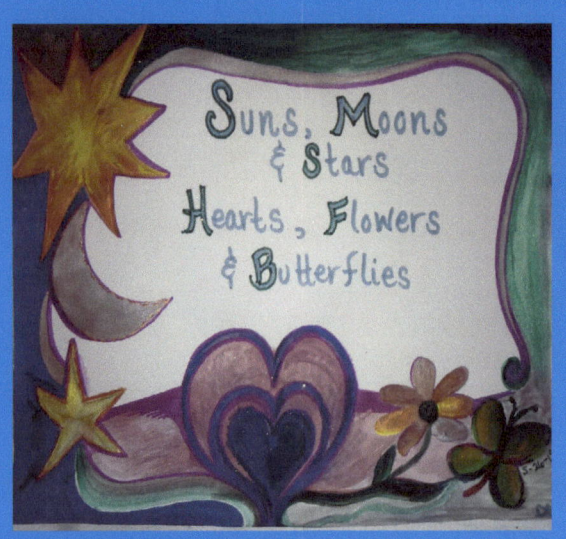

ARTIST LECTURE SERIES
1. Exploring the Use of Mixed Media Materials
2. Mixed Media Arts Curriculum and Integration
3. Ways to Sustain a Mixed Media Arts Curriculum

Immersing oneself into healthy hobbies helps with overall well-being and self-esteem. Many of my creations are a form of therapeutic healing in times of high stress.

I use a variety of materials to create images. These include paints, glue, yarn, fabric and recycled items that would otherwise be thrown away. I am trying to do a little part to save the environment while creating a little more peace and harmony.

Exploring the Use of Mixed Media Materials

Mixed media is a way to incorporate and design an art curriculum. Learn about the benefits of bringing arts into the classroom or home environment and the positive impact for a fine-motor, social-emotional, cognitive, and language development. This is session 1 of the Artist Lecture Series..

Mixed Media Arts Curriculum and Integration

Explore mixed media arts. Current art programs in use will be discussed and look to improve and enhance through the use of mixed media. Arts in the classroom or home environment enhances self-esteem and promotes healthy development. Create a sign to market your new mixed media arts curriculum. Materials included. This is session 2 of the Artist Lecture Series.

Ways to Self-Sustain a Mixed Media Arts Curriculum

Learn strategies to self-sustain a mixed media arts curriculum in classroom or home environments. In-depth discussions relating to arts curriculum to foster self-esteem and healthy social-emotional development. Participants will use mixed media materials to create marketing tools. Bring a t-shirts for creating. All other materials provided. This is session 3 of the Artist Lecture Series.

Artist Lecture Series - Overview

Exploring the Use of Mixed Media Materials

Mixed media is a way to incorporate and design an art curriculum. Learn about the benefits of bringing arts into the classroom or home environment and the positive impact for a fine-motor, social-emotional, cognitive, and language development. This is session 1 of the Artist Lecture Series..

Artist Lecture Series - Session 1: Introduction

Take a moment to reflect on a time you used mixed media arts materials.
How did you feel at the time?

Exploring the Use of Mixed Media Art Materials

Exploring the Use of Mixed Media Materials

1. Introduction to the Artists Lecture Series (5 minutes)
2. Reflection Activity: Participants will reflect on a time they used mixed media arts materials. Participants will be asked to share if they would like to. (5 minutes)
3. Gallery Walk: As a group participants will walk the gallery and learn how mixed media materials are used. During the walk there will be time for open discussion and questions. (20 minutes)
4. Small Groups Activity (10 minutes) Discuss at small groups ways the programs are currently using an arts curriculum.
5. Open Discussion (10 minutes) Discuss the benefits they see on the children's development while they participate in arts curriculum.
6. Activity - (10 minutes) How can Mixed Media foster healthy child development? Participants will list specific activities to encourage language, cognitive, fine-motor and social-emotional development.
7. Hands-On Activity: (30 minutes) Participants will explore mixed media materials and work with the different types. Participants will study shape, size, texture, color and type of materials. While exploring participants will discuss possible ways to use the materials.
8. Open Discussion (15 minutes) Discuss types of mixed media materials.
9. Professional Action (10 minutes) What ways can you enhance your current arts curriculum to use mixed media?
10. Wrap-up (5 minutes) Give brief overview for next artist lecture series/training session. Remind participants to complete evaluation and then distribute certificates.

Total time: 2 hours

Artist Lecture Series - Session 1

What ways can you enhance your current arts curriculum to use mixed media?

Professional Action - Session 1

Mixed Media Arts Curriculum and Integration

Explore mixed media arts. Current art programs in use will be discussed and look to improve and enhance through the use of mixed media. Arts in the classroom or home environment enhances self-esteem and promotes healthy development. Create a sign to market your new mixed media arts curriculum. Materials included. This is session 2 of the Artist Lecture Series.

Artist Lecture Series - Session 2: Introduction

Take a moment to reflect on the use mixed media arts materials implemented in the classroom or your home environment.

Mixed Media Arts Curriculum and Integration

1. Introduction to the Artists Lecture Series (5 minutes)
2. Reflection Activity: Participants will reflect on the use mixed media arts materials in the classroom or home environment. Participants will be asked to share if they would like to. (5 minutes)
3. Gallery Walk: As a group participants will walk the gallery and discuss how mixed media materials are layered over mediums. During the walk there will be time for open discussion and questions. (20 minutes)
4. Small Groups Activity (10 minutes) Discuss at small groups ways they implemented the use of the mixed media art curriculum into their environments.
5. Open Discussion (10 minutes) Discuss the benefits they see while participating in arts curriculum.
6. Activity - (10 minutes) How can Mixed Media foster healthy development? Participants will brainstorm additional activities to bring into the environment.
7. Hands-On Activity (30 minutes) Participants will use mixed media materials to create a marketing tool (a circular sign) to bring back to their center to help promote their new mixed media arts integration.
8. Open Discussion (15 minutes) How to find support for your arts curriculum. What are ways to encourage others to be involved?
9. Professional Action (10 minutes) What ways can you promote your mixed media arts curriculum?
10. Wrap-up (5 minutes) Give brief overview for next artist lecture series/training session.

Remind participants to complete evaluation and then distribute certificates.
Total time: 2 hours

Artist Lecture Series - Session 2

What ways can you promote your mixed media arts curriculum?

Professional Action - Session 2

Ways to Self-Sustain a Mixed Media Arts Curriculum

Learn strategies to self-sustain a mixed media arts curriculum in classroom or home environments. In-depth discussions relating to arts curriculum to foster self-esteem and healthy social-emotional development. Participants will use mixed media materials to create marketing tools. Bring a t-shirts for creating. All other materials provided. This is session 3 of the Artist Lecture Series.

Artist Lecture Series - Session 3: Introduction

Take a moment to reflect on the use mixed media arts materials.

Ways to Self-Sustain a Mixed Media Arts Curriculum

Ways to Self-Sustain a Mixed Media Arts Curriculum

1. Introduction to the Artists Lecture Series (5 minutes)
2. Reflection Activity: Participants will reflect on the use mixed media arts materials. Participants will be asked to share if they would like to. (5 minutes)
3. Gallery Walk: As a group participants will walk the gallery and discuss what types of mixed media styles have been incorporated into their classroom or home environments. Participants will have time to discuss specifics and ask questions about techniques. (20 minutes)
4. Small Groups Activity (10 minutes) Discuss at small groups ways they implemented the use of the mixed media art curriculum into their environments. Is the new curriculum making an impact? How can you see this?
5. Open Discussion (10 minutes) Discuss the benefits they see on the while they participating in arts curriculum - provide specific examples. Share and Reflect as a group.

Artist Lecture Series - Session 3

Ways to Self-Sustain a Mixed Media Arts Curriculum

6. Activity - (10 minutes) How can Mixed Media foster healthy development? Participants will brainstorm additional ways to bring mixed media into the classroom or home environment.
7. Hands-On Activity (30 minutes) Participants will use mixed media materials to create a marketing tool (a circular sign or if they brought one, a t-shirt) to bring back to their center to help promote their new mixed media arts integration.
8. Open Discussion (15 minutes) What ways can you think of to self-sustain your mixed media arts curriculum. Can you incorporate family support into the process?
9. Professional Action (10 minutes) Come up with three goals for the next six months to sustain your program. The first to accomplish within the next month, the second within the first 3 months and then the third within the next six months. If willing, some open sharing of their their goals might take place with the group.
10. Wrap-up (5 minutes) Conclusion on the series: explored topic, studied in depth and implemented a new mixed media arts program into their classrooms over a period of time and reflected on the positive impacts for children's health development. Remind participants to complete evaluation and then distribute certificates.

Total time: 2 hours

Artist Lecture Series - Session 3

Come up with three goals for the next six months to sustain your program.
1. The first to accomplish within the next month.
2. The second within the first three months.
3. The third within the next six months.

Professional Action - Session 3

Danielle Lucas, Experimental Expressionist

Thank you for your interest in Mixed Media Arts!

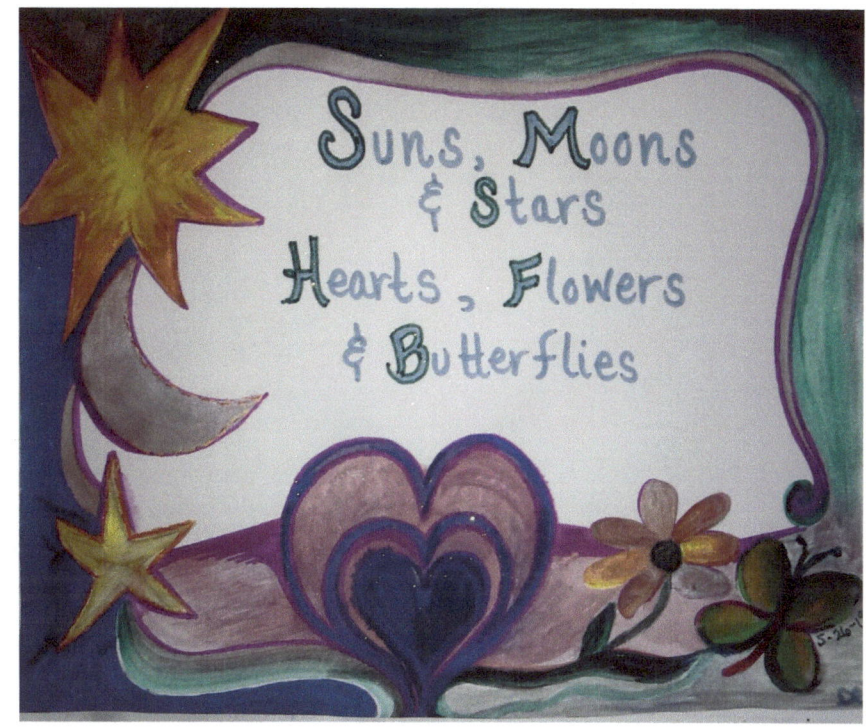

https://www.amazon.com/handmade/Experimental-Expressionist?ref=hnd_dp_smp_txt_c

www.ingramcontent.com/pod-product-compliance
Lightning Source LLC
Chambersburg PA
CBHW041315180526
45172CB00004B/1102